The Blue Day Book

The Blue Day Book

A Lesson in Cheering Yourself Up

Bradley Trevor Greive

Andrews McMeel
PUBLISHING®

Andrews McMeel Publishing
a division of Andrews McMeel Universal
1130 Walnut Street, Kansas City, Missouri 64106

www.andrewsmcmeel.com

19 20 21 22 23 WKT 10 9 8 7 6 5 4 3

ISBN: 978-0-7407-9187-1

Library of Congress Control Number: 2009937807

Book design by Holly Swayne
Images hand colored by Tim Clift

Photo Credits
Corbis Australia Pty Ltd www.corbis.com
Getty Images www.gettyimages.com
Photolibrary www.photolibrary.com
Emerald City Images www.emeraldcityimages.com.au
D. Robert Franz www.franzfoto.com
© **Frans Lanting** www.lanting.com

ATTENTION: SCHOOLS AND BUSINESSES
Andrews McMeel books are available at quantity discounts with bulk purchase
for educational, business, or sales promotional use. For information,
please e-mail the Andrews McMeel Publishing Special Sales Department:
specialsales@amuniversal.com.

To my wonderful parents, Fay and Trevor Greive,
who never stopped taking me out to see the world
even after I was bitten by penguins, three times.

Foreword

If you've watched my wildlife programs on Animal Planet, about giant Alaskan brown bears, tiny lizards, and extraordinary insects, you already know that I have great affection for animals of all shapes and sizes. But you may not know that I happen to have a particular soft spot for frogs; I like their spongy tummies and oh-so-sensitive toes. I like their delicate skin that feels like refrigerated velvet, and I love the way their large luminous eyes stare at the world with an unfettered sense of wonder. I especially enjoy listening to frogs celebrate the arrival of rain with a yodeled belching of gargled throat song, calling our attention to the fact that hope has been rewarded and life renewed. Maybe this froggy fascination stems from my childhood in Australia, the driest inhabited continent on planet Earth, where water is so scarce and so precious that frogs have become proxy ambassadors of good fortune. Or perhaps, deep down, I'm just like so many little boys splashing about in creeks and muddy ponds who never really grew up. Opinions vary.

Nevertheless, if you had told me that a frog would one day change my life, I would not have believed you. Yet that is exactly what happened. Looking back to 1998, when I first fell for the grumpy blue face that now adorns the cover of *The Blue Day Book*, I still find it hard to comprehend the extraordinary impact this little edition has had on my life and how it has reached into the hearts and homes of so many people throughout the world.

The Blue Day Book's conception was hardly immaculate, though certainly heartfelt. On the day I first dreamed up this little book, I was living and working in grunge-chic squalor in a seedy artist's loft located directly opposite the largest railway station in Australia. Whenever a train arrived or departed, roughly every ten seconds or so, my apartment shuddered like a sick dog, panicked high-velocity vermin scurried about, and termite snow rained down upon me. To make matters worse, I was fiscally impaled, romantically dislocated, and I had caught a terrible flu during the coldest, wettest winter I can remember. I was not a happy camper.

Rummaging desperately through all my pockets for loose change, I discovered I had just enough money to catch a taxi into town to watch a movie or eat a hot meal—but sadly, not both. Braving the rain, I puddle-jumped down the busy streets, slid spinelessly into a greasy spoon, ordered soup and a burger, and began to scribble my tortured feelings on a paper napkin. I wrote a lot of nonsense and some rather bad poetry, none of it worth mentioning except for one particular line that stood out in my mind:

"The world turns gray and I grow tired."

Though hardly the musings of Robert Frost, I wrote this line again and again, and even illustrated it with an exhausted tortoise collapsed helplessly on its back. It seemed to be the perfect visual metaphor for how I felt at that exact moment. Six years after my military career ended abruptly due to a tropical lung infection, having wholeheartedly committed myself to a writing career, I had nothing at all to show for my labors except seven unpublished books and an enormous pile of rejection letters. On this particular day I felt defeated. All the color had faded from my worldview, and I was too miserable, weary, and humiliated to take another step.

After wallowing in the pungent pudding of self-pity for a time, it suddenly struck me how interesting it would be if the world really were devoid of color, or at least if I couldn't see it. Imagine if we saw only black, white, and shades of gray. Then it occurred to me that a great many animals see the world very differently from us all the time, dogs for example, and they don't seem too depressed about it. On the contrary, animals thrive despite all sorts of hardship, and they just don't let the little things get them down. And when things do get tough, they don't resort to Prozac or pour a cheap bottle of wine into their face—though I'll admit imagining a down-and-out kangaroo chugging a bottle of Yellow Tail did amuse me.

Before I knew it, I was smiling, and the smile became a chuckle as I remembered all the hilarious black-and-white animal photos I had seen in *Life* magazine when I was growing up in Singapore and Hong Kong. Pretty soon I realized I was taking myself and my setbacks far too seriously. No matter how tough things were, at least I was doing what I most wanted to do. I had a lot to be grateful for and a great deal to look forward to. *The Blue Day Book* was born.

I have many people to thank for the creative freedom I now enjoy, especially my beloved literary agent, Sir Albert Zuckerman, of Writers House, New York, and my original editor, Christine Schillig, of Andrews McMeel Publishing in Kansas City. And while I am eternally grateful to my extended publishing family around the world, and all the numerous talented photographers, editors, designers, and agents I work with every day, most of all I really want to thank you, dear reader, for giving me a chance. I had no idea so many people would enjoy the same slightly twisted perspectives that I do, or that they would see themselves and their loved ones in each of the incredible animal photographs as I have (I used to relate most to the bear cub on page 18, although these days I feel closer and closer to the cat on page 27).

Never in my wildest dreams did I imagine *The Blue Day Book* would become the most popular gift book in publishing history, and it feels both quite wonderful and supremely humbling to think of how many people have chuckled and sighed at the same thoughts and images that first moved me to laughter and tears. And, in a happily strange way, it also makes me feel very hopeful about our collective future in that something so simple, and frankly a little silly at times, can bring us together for a moment to reflect on what matters most: that there is only one you, and you have only one life to live. Yes, we are all flawed, and we all make stupid and sometimes painful mistakes, and to be blunt, sometimes life really sucks. But if we can acknowledge that others hurt as we do and yet they somehow manage to laugh at themselves and rise up to try again, then perhaps so can we.

The success of *The Blue Day Book* has certainly changed my life and, I'm glad to say, a few other lives as well. Proceeds from this book, and others in the series, now support at least one major wildlife conservation project on every continent, preserving all manner of endangered species, including Malayan sun bears and Burmese roof turtles in Asia, okapi and painted hunting dogs in Africa, Kamchatkan brown bears in Russia, migratory seabirds in Antarctica, numerous American and Australian mammals, and yes, even a couple of rare and precious frogs (including the green and golden bell frog, in eastern Australia, and the hilariously named mountain chicken, on the Caribbean island of Montserrat).

Look, I'm no psychiatrist, and I'm far from perfect, but I'm unashamedly proud of the times I have managed to pick myself up off the floor and try again. I'm grateful for the life I am living, and the wonderful people I share it with, and I'm honored to have had a chance to help others—be they human or frog. Suffice it to say that, for me, there are just so many special memories and deep emotions wrapped up in *The Blue Day Book* that I merely have to look at my grouchy amphibious friend on the cover and it makes me smile. I can't know what you're going through right now, but if you are facing great adversity, or simply having a lousy day, I sincerely hope this little book helps you smile too.

The Blue Day Book

Everybody has blue days.

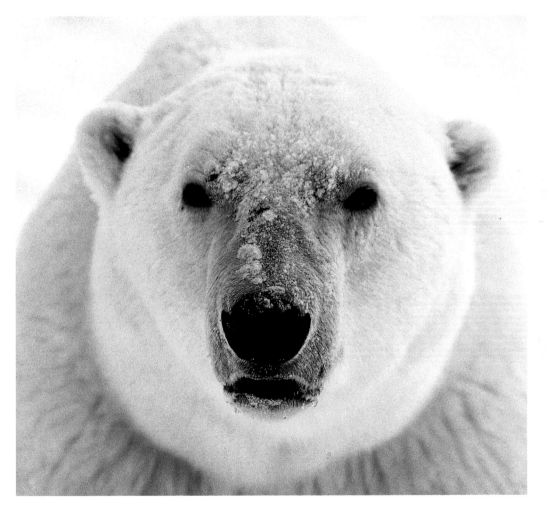

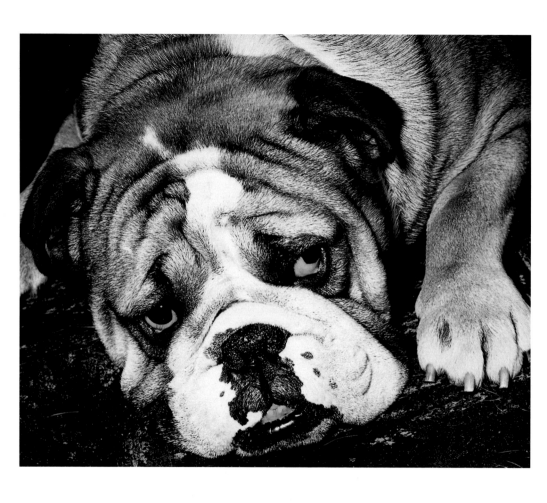

These are miserable days when you feel lousy,

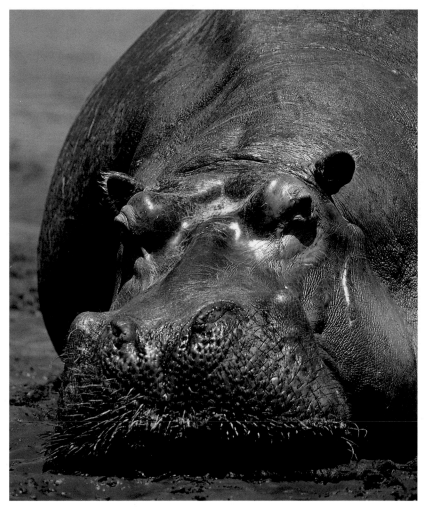

grumpy,

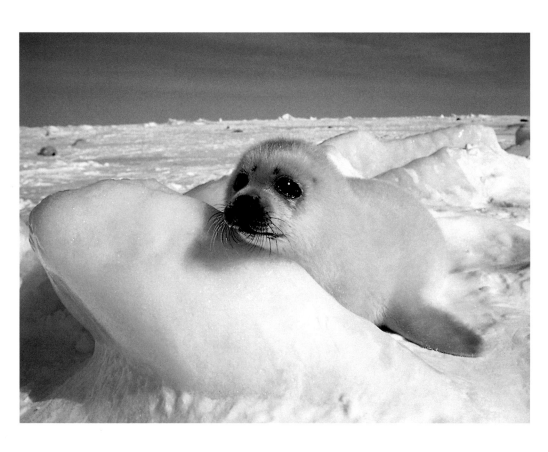

lonely,

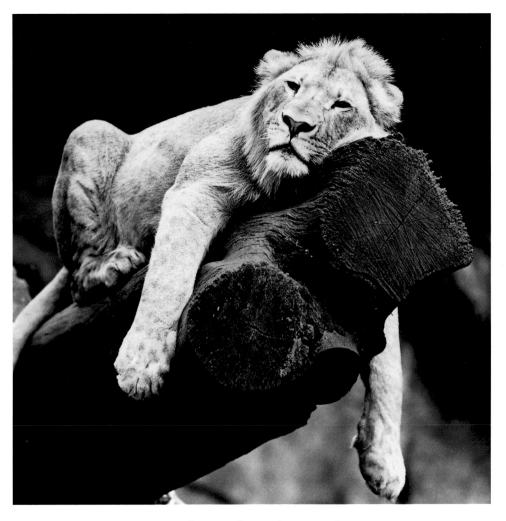

and utterly exhausted.

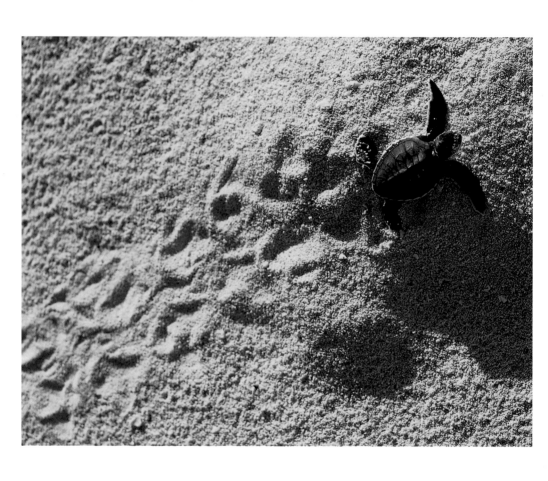

Days when you feel small and insignificant,

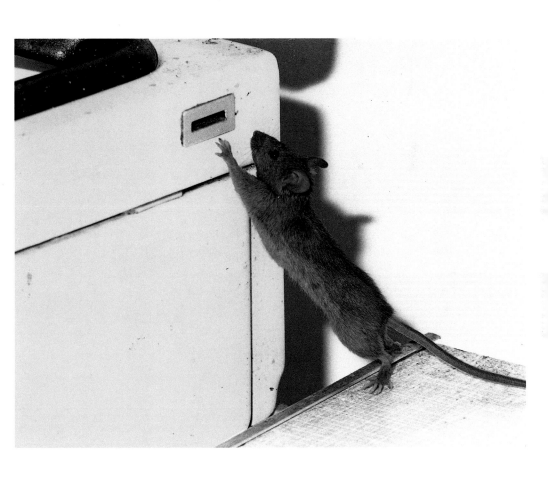

when everything seems just out of reach.

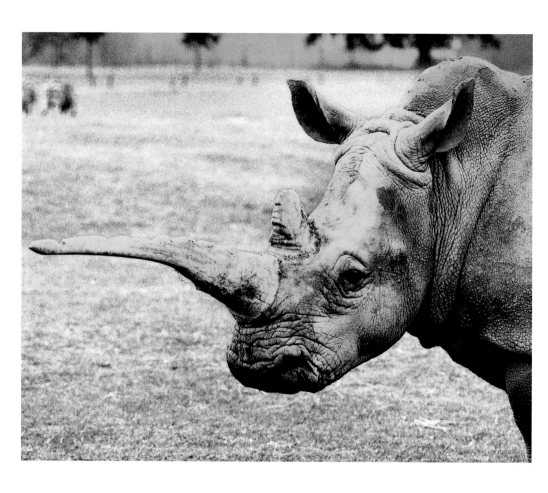

You can't rise to the occasion.

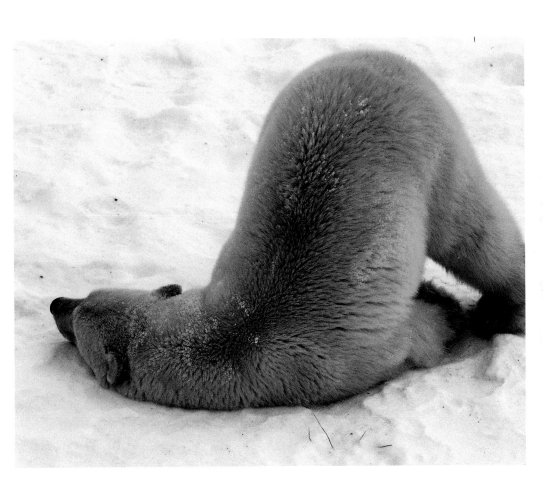

Just getting started seems impossible.

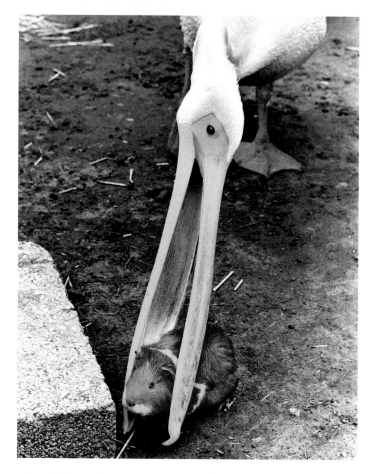

On blue days you can become paranoid
that everyone is out to get you.
(This is not always such a bad thing.)

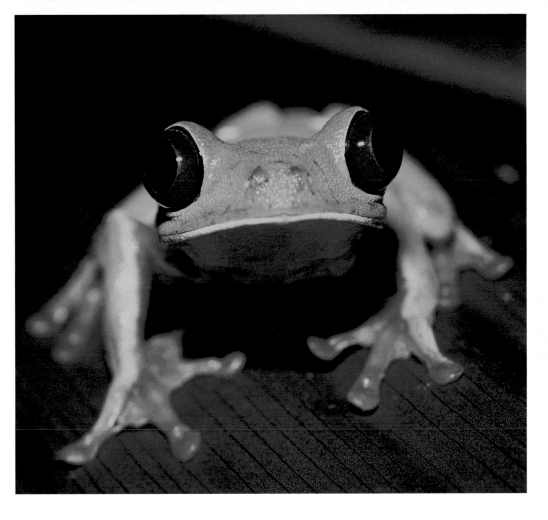

You feel frustrated and anxious,

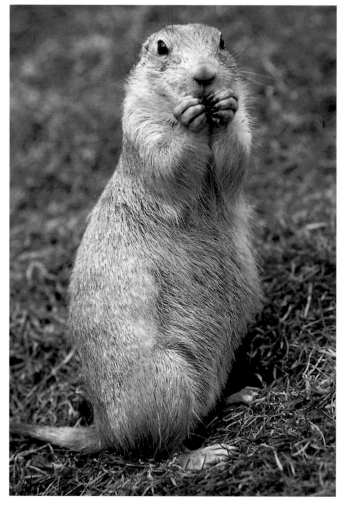

which can induce a nail-biting frenzy

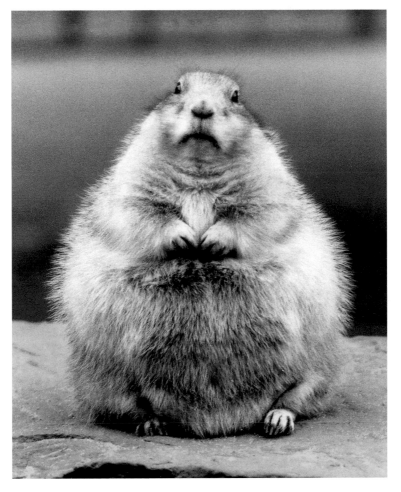

that can escalate into a triple-chocolate-mud-cake-
eating frenzy in a blink of an eye!

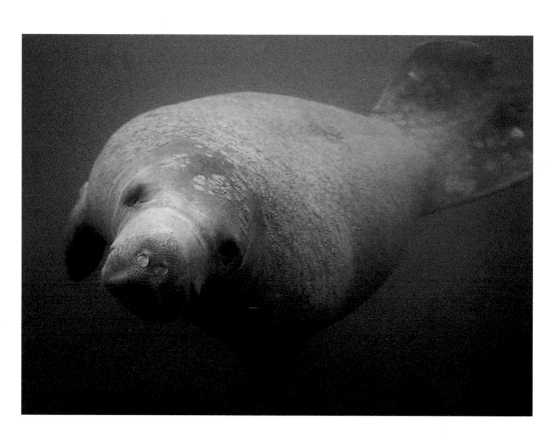

On blue days you feel like you're floating
in an ocean of sadness.

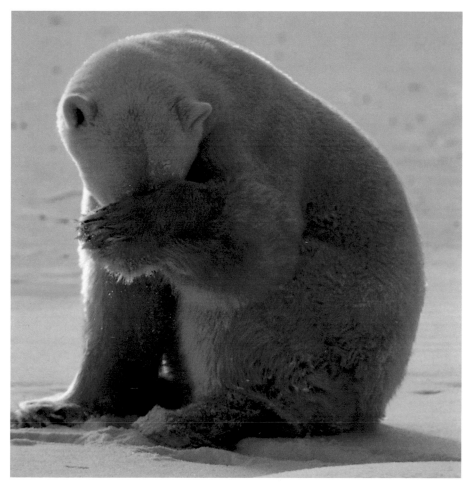

You're about to burst into tears at any moment
and you don't even know why.

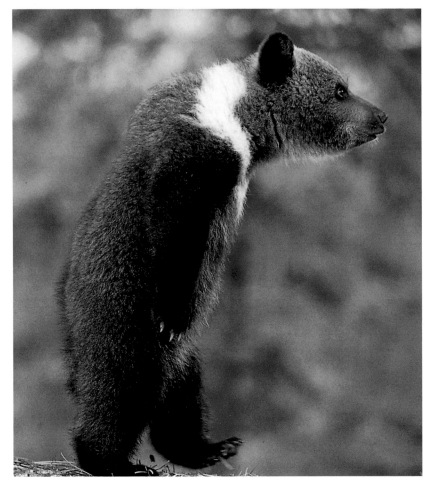

Ultimately, you feel like you're wandering
through life without purpose.

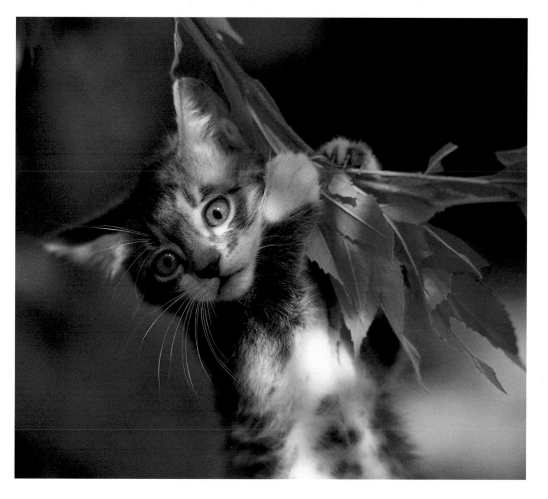

You're not sure how much longer
you can hang on,

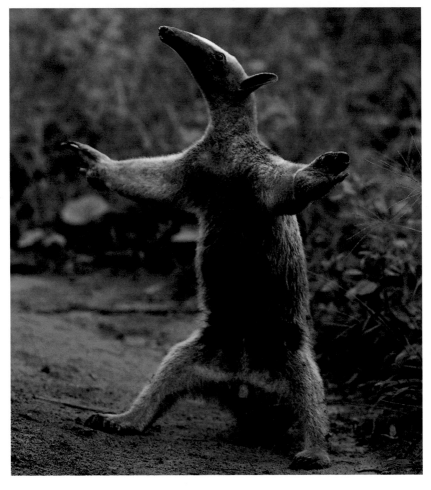

and you want to cry out,
"Will someone please put me out of my misery!"

It doesn't take much to bring on a blue day.

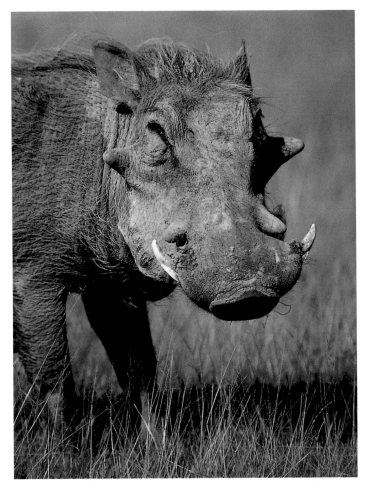

You might just wake up
not feeling or looking your best,

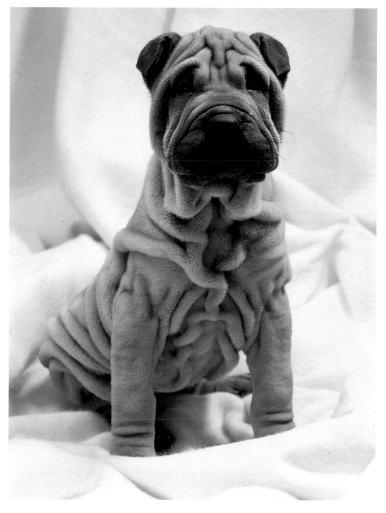

find some new wrinkles,

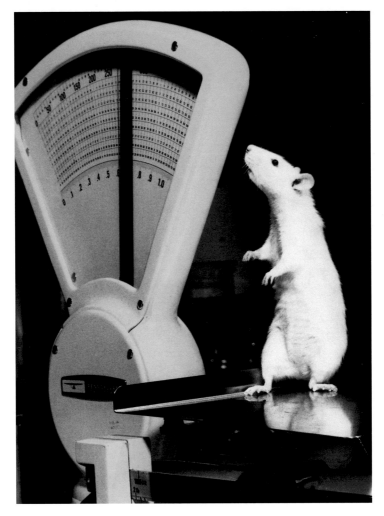

put on a little weight,

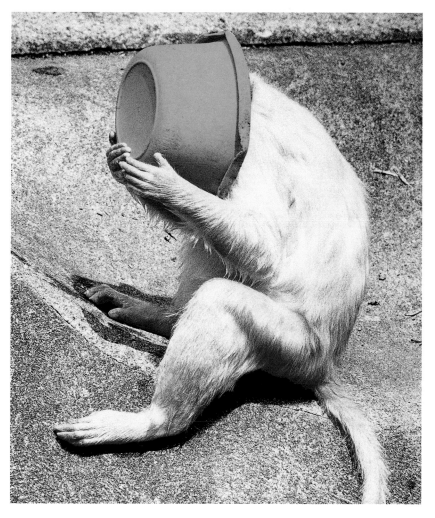

or get a huge pimple on your nose.

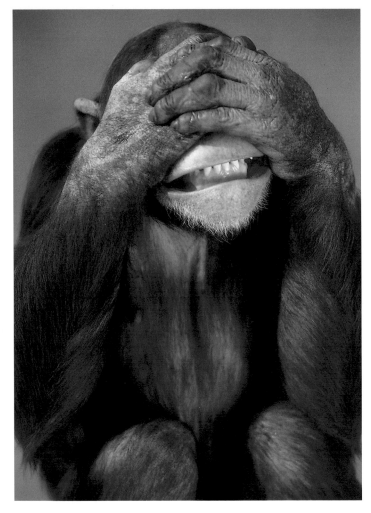

You could forget your date's name

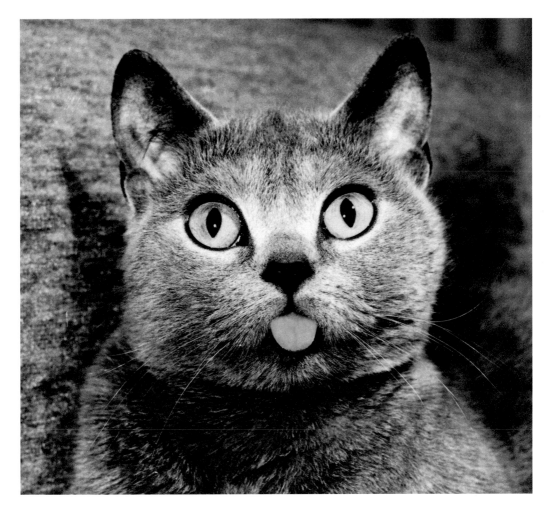

or have an embarrassing photograph published.

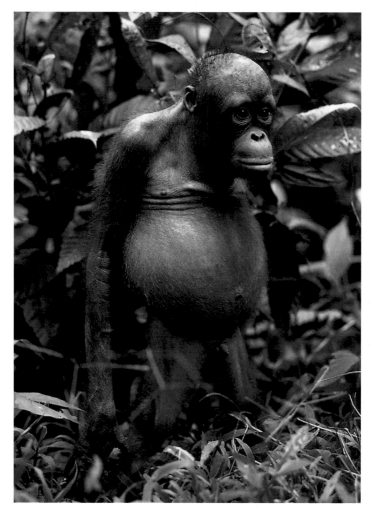

You might get dumped, divorced, or fired,

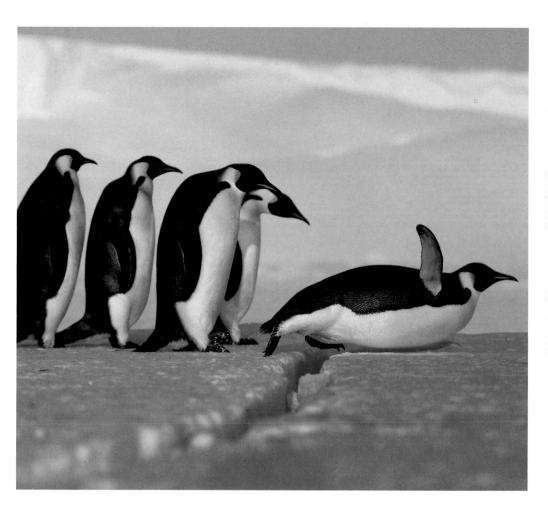

make a fool of yourself in public,

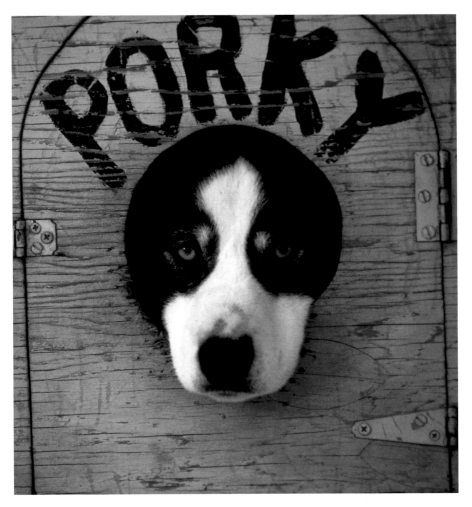

be afflicted with a demeaning nickname,

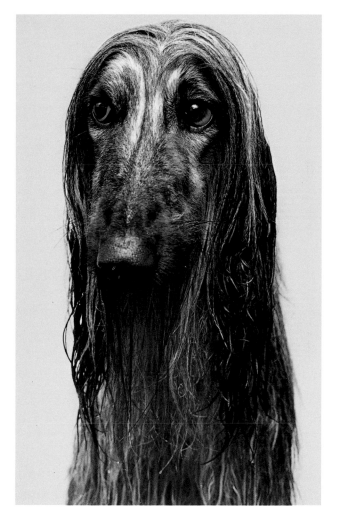

or just have a plain old bad-hair day.

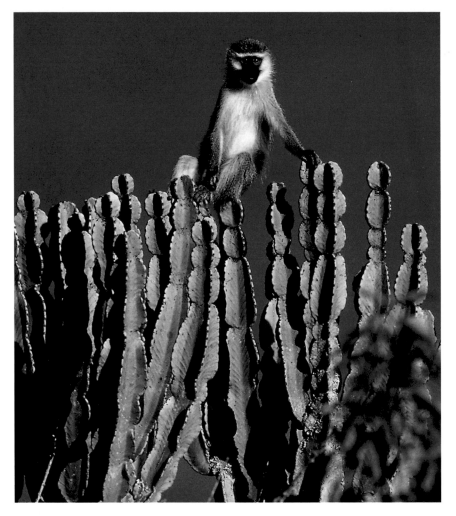

Maybe work is a pain in the butt.

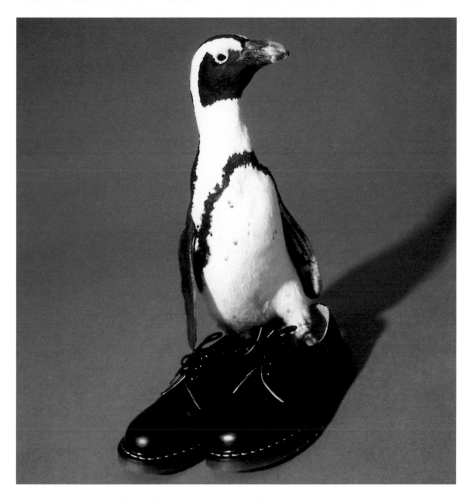

You're under major pressure
to fill someone else's shoes,

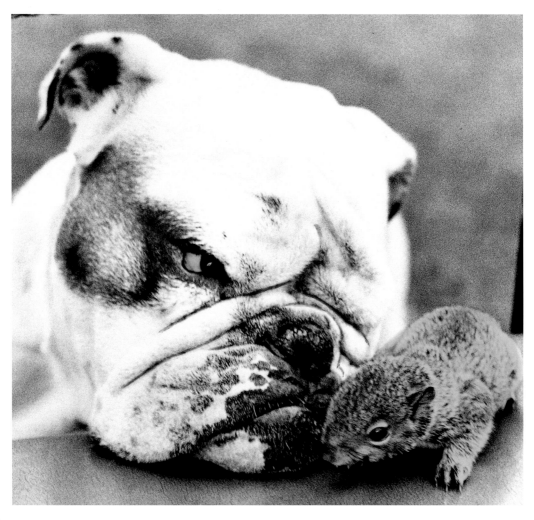

your boss is picking on you,

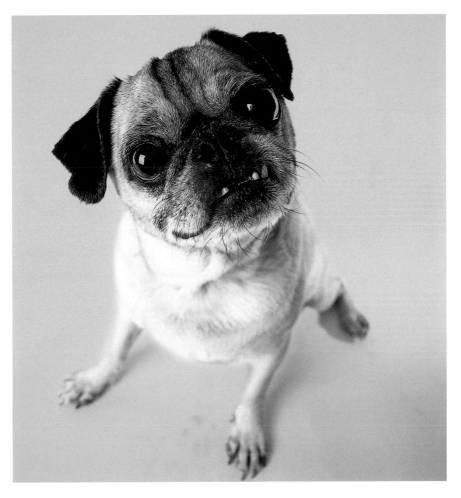

and everyone at work
is driving you crazy.

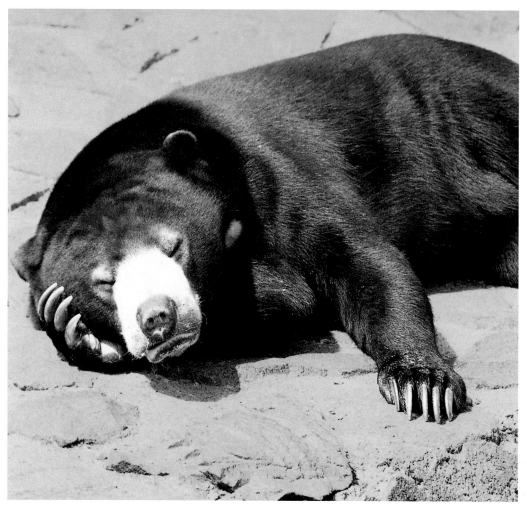

You might have a splitting headache,

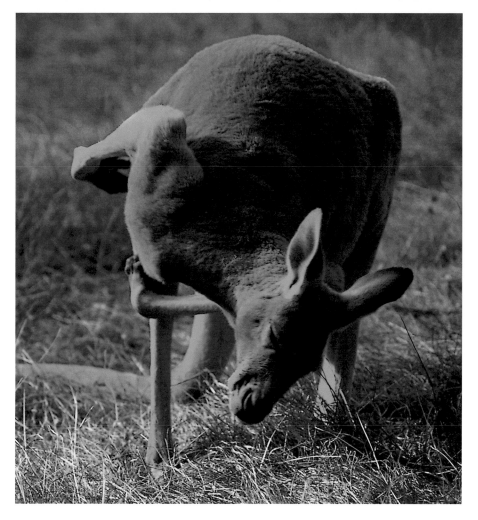

or a slipped disk,

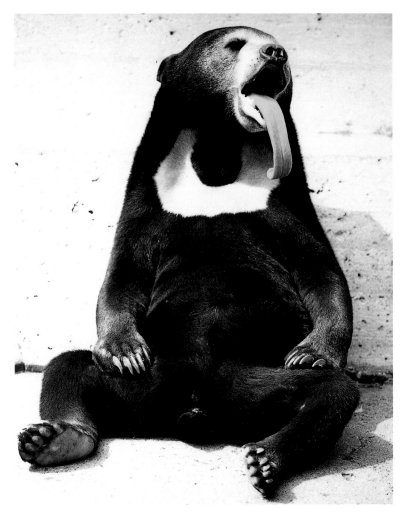

bad breath,

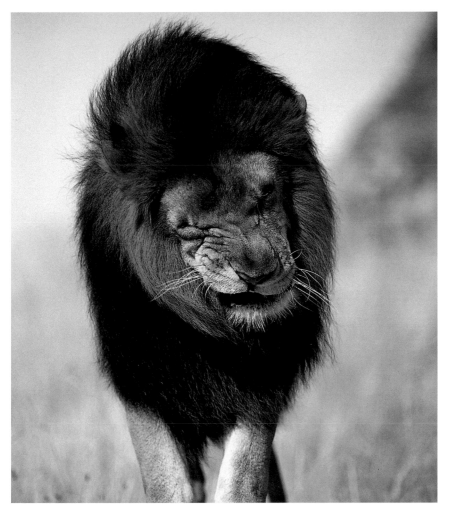

a toothache,

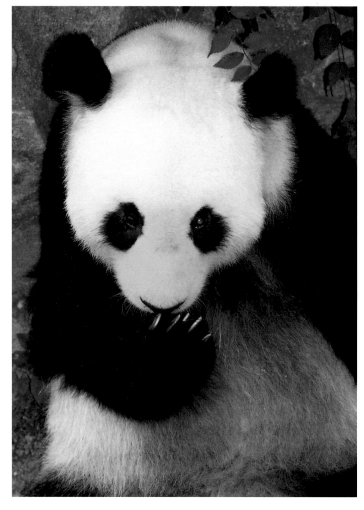

chronic gas,

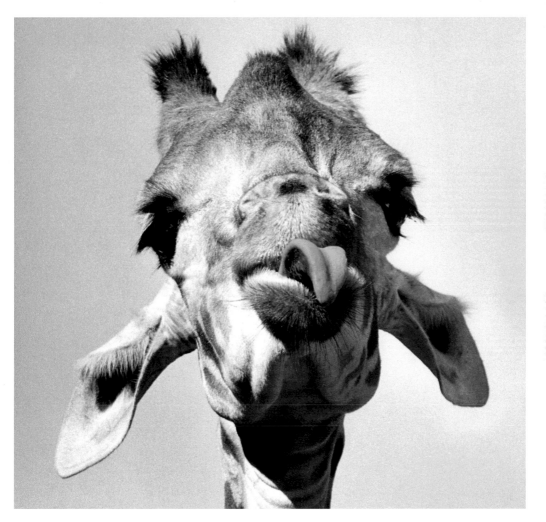

dry lips,

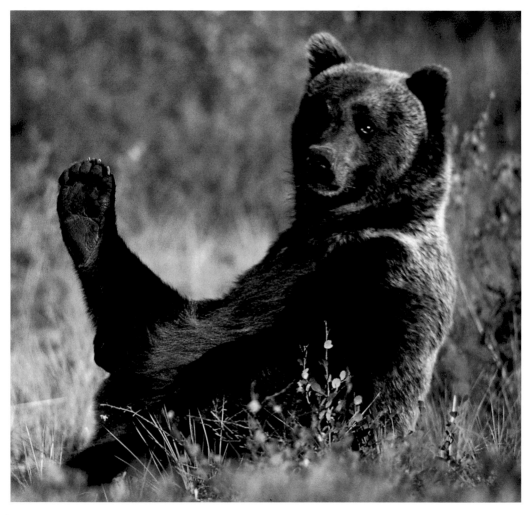

or a nasty ingrown toenail.

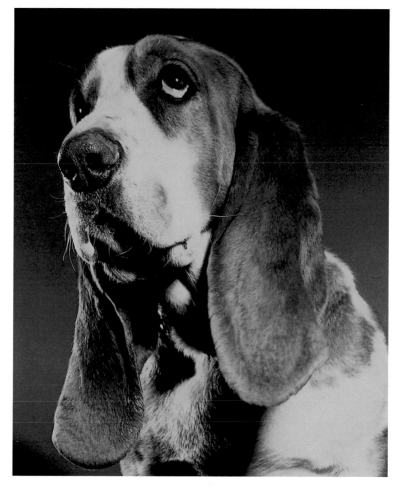

Whatever the reason, you're convinced
that someone up there doesn't like you.

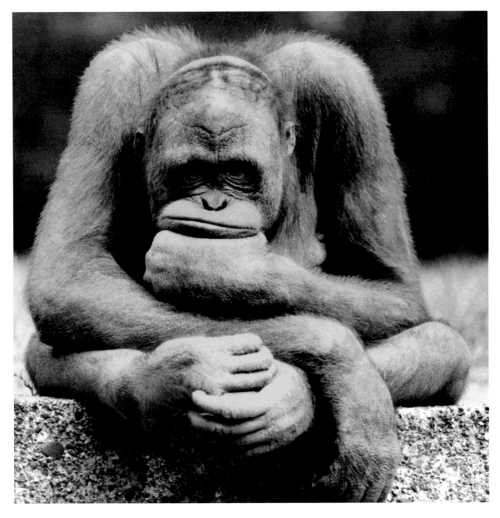

Oh what to do, what to dooo?

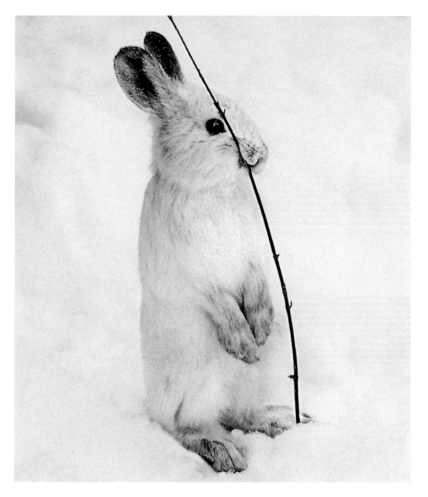

Well, if you're like most people, you'll hide behind a flimsy belief that everything will sort itself out.

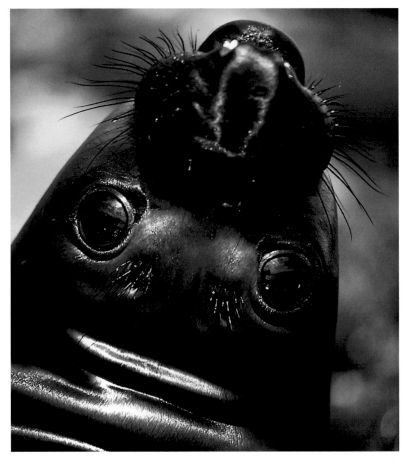

Then you'll spend the rest of your life
looking over your shoulder, waiting for everything
to go wrong all over again.

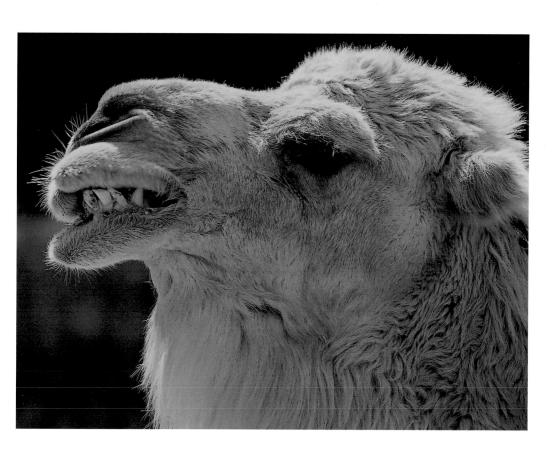

All the while becoming crusty and cynical

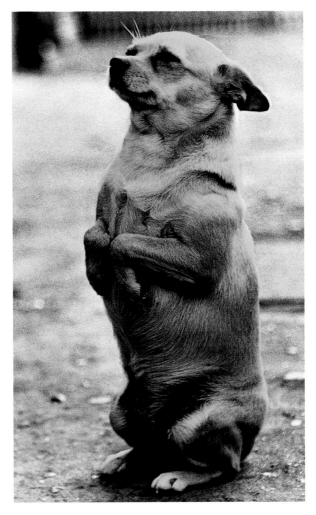

or a pathetic, sniveling victim,

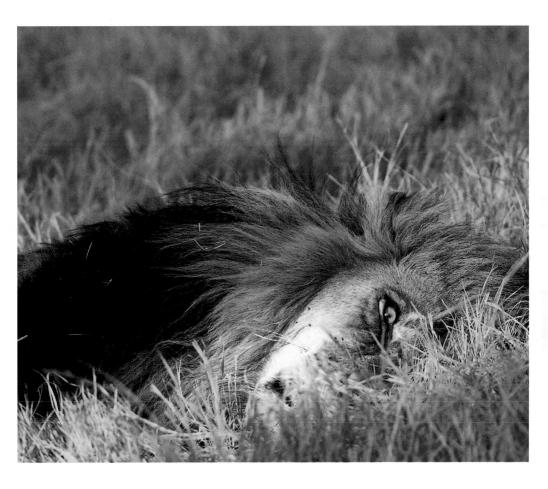

until you get so depressed that you lie down
and beg the earth to swallow you up

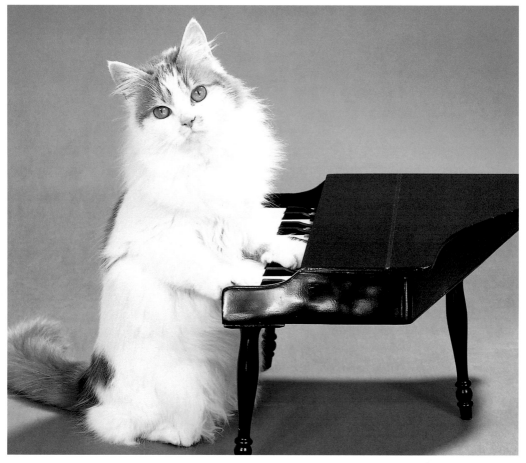

or, in the most serious cases,
play Billy Joel songs again and again and again,
until you achieve an altered state of consciousness.

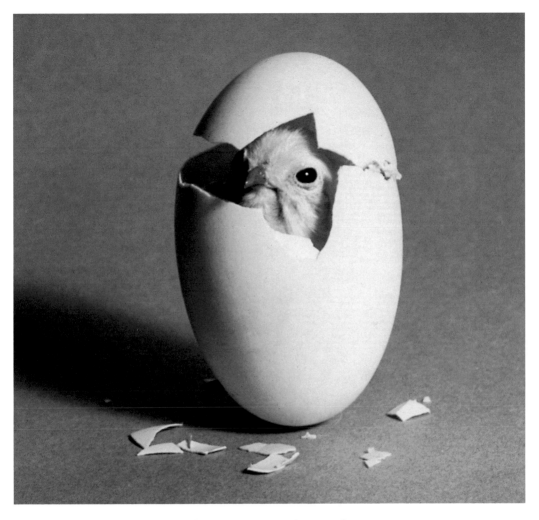

This is crazy, because you're only young once

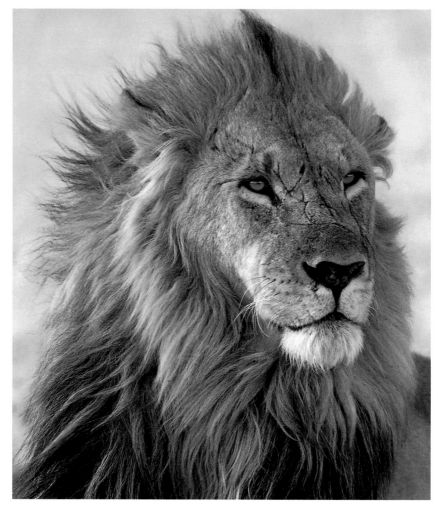

and you're never old twice.

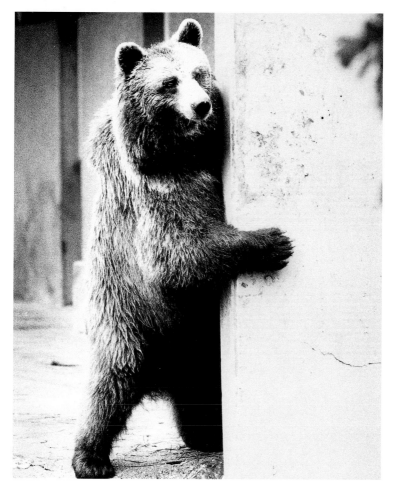

Who knows what fantastic things are in store
just around the corner?

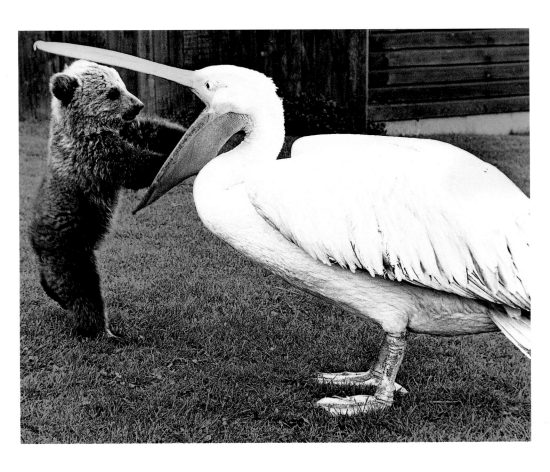

After all, the world is full
of amazing discoveries,

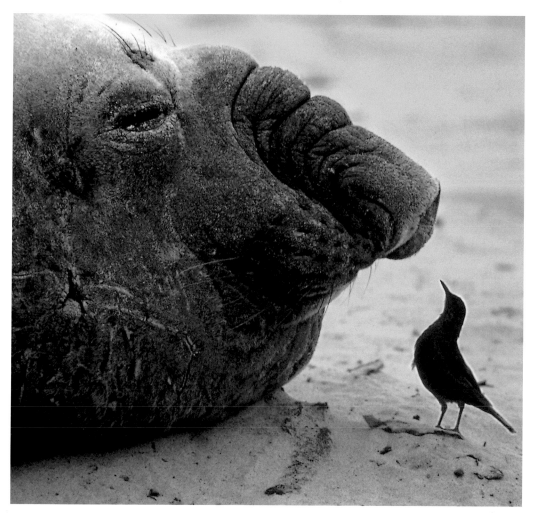

things you can't even imagine now. 55

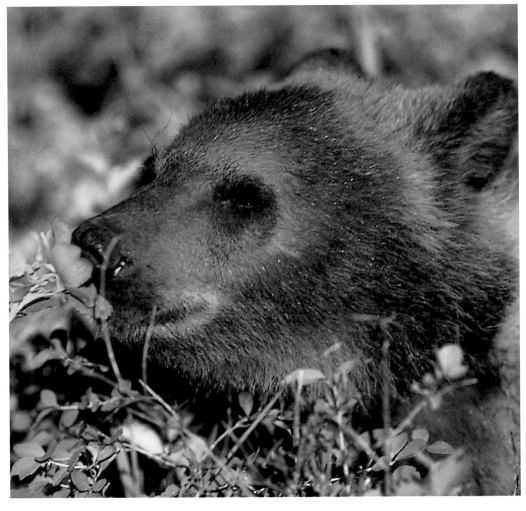

There is fresh air and fragrant sniffs aplenty

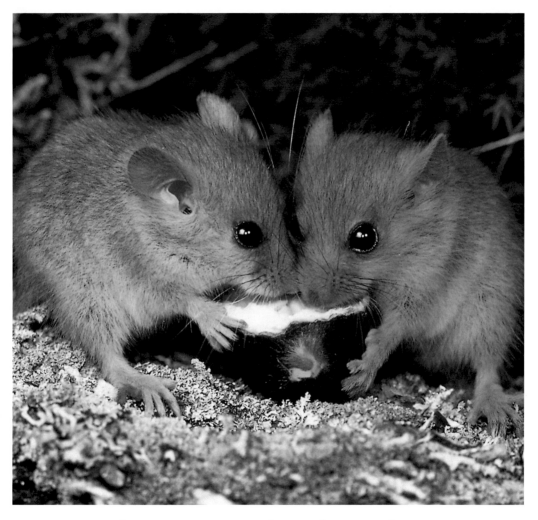

and scrumptious snacks to share and savor.

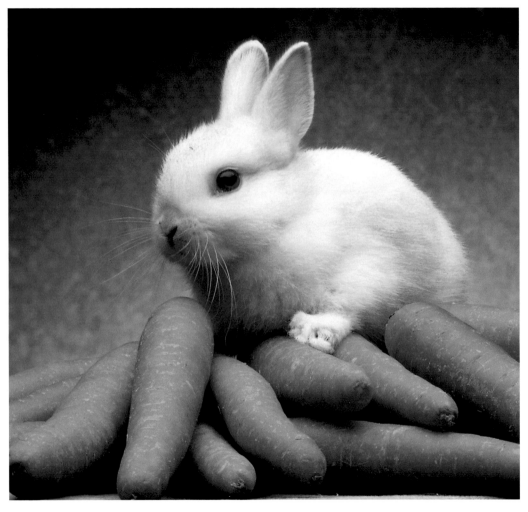

Hey, you might end up fabulously rich

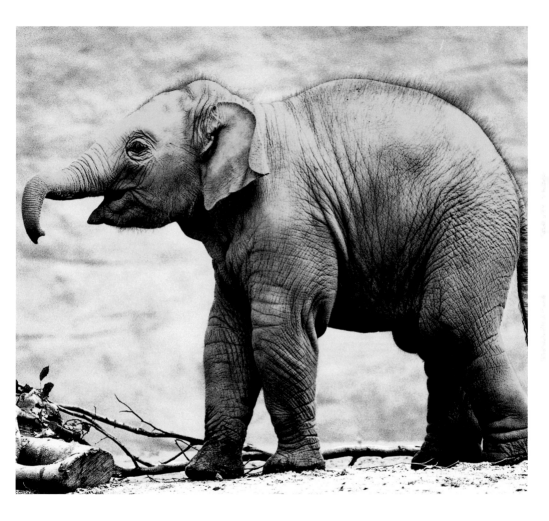

or even become a huge superstar (one day).

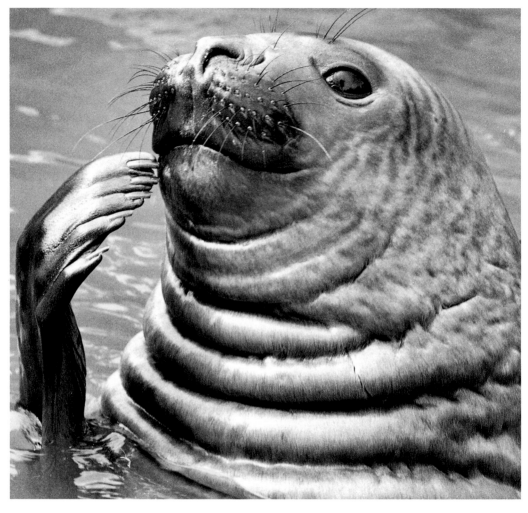

Sounds good, doesn't it?

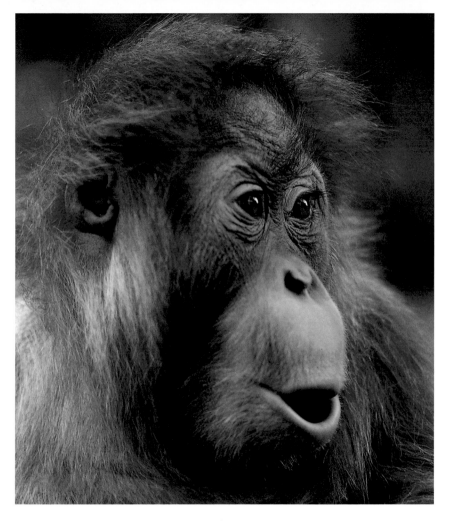

But wait, there's more!

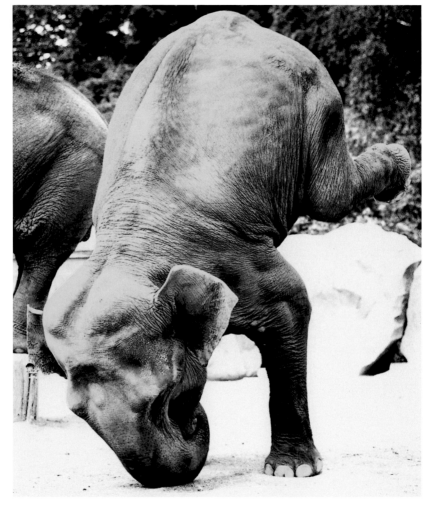

There are cartwheels

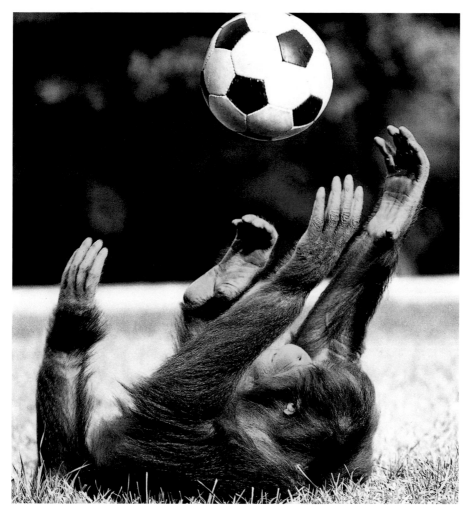

and games to play

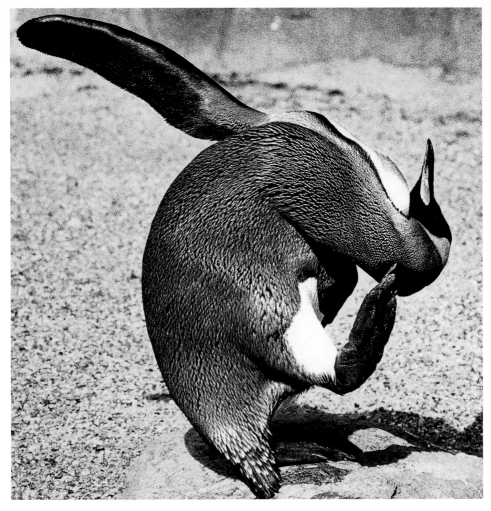

and Vinyasa Yoga (whatever that is)

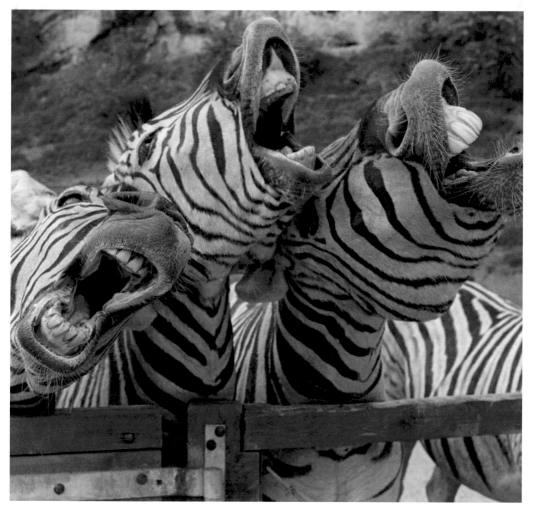

and karaoke power ballads

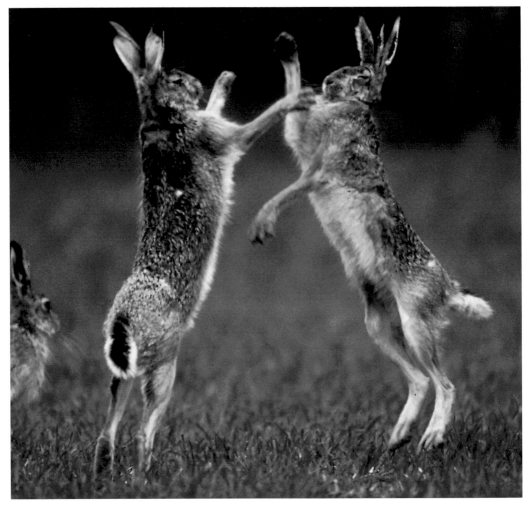

and wild, crazy, bohemian dancing.

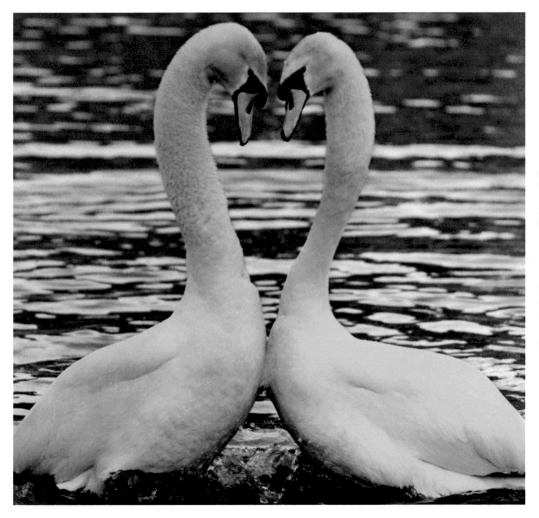

But best of all, there's romance.

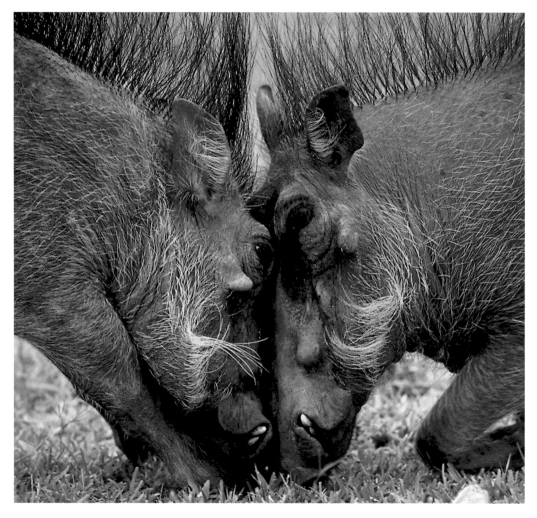

Which means long dreamy stares,

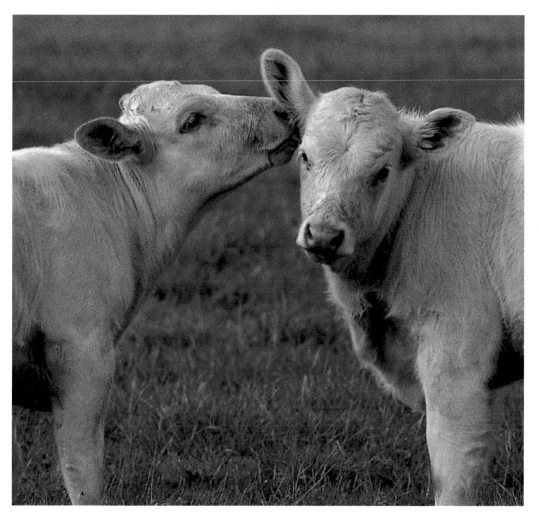

whispering sweet nothings, ⁶⁹

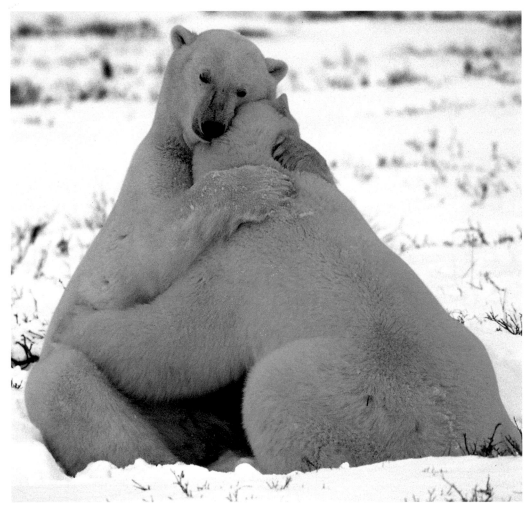

cuddles,

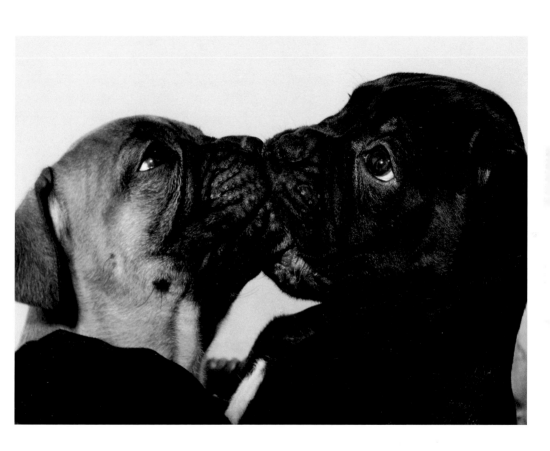

smooches,

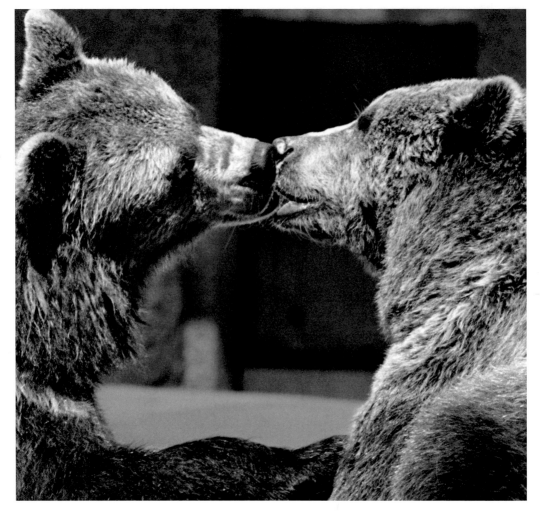

more smooches,

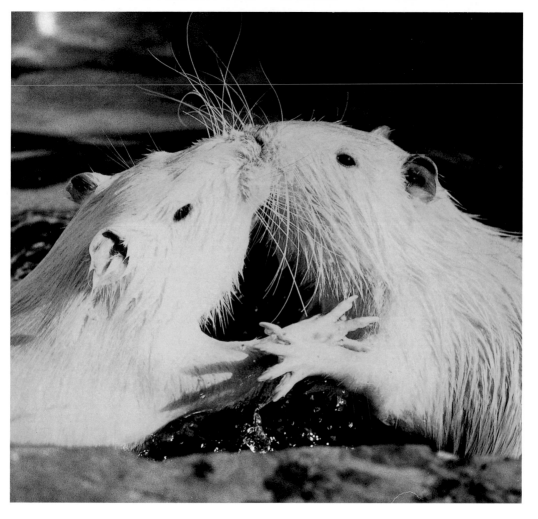

and even more smooches,

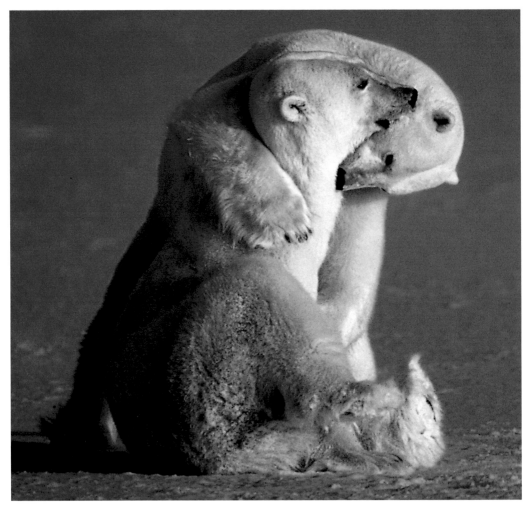

a frisky love bite or two,

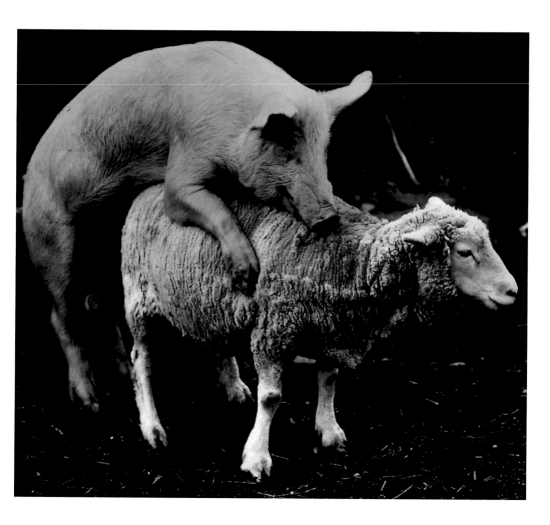

and then, well, anything goes.

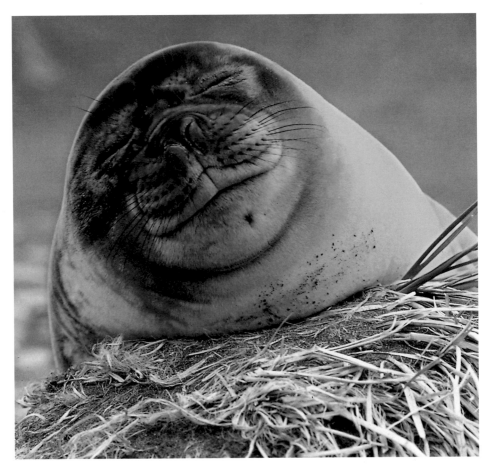

So how can you find that blissful
"just sliding into a hot bubble bath"
kind of feeling?

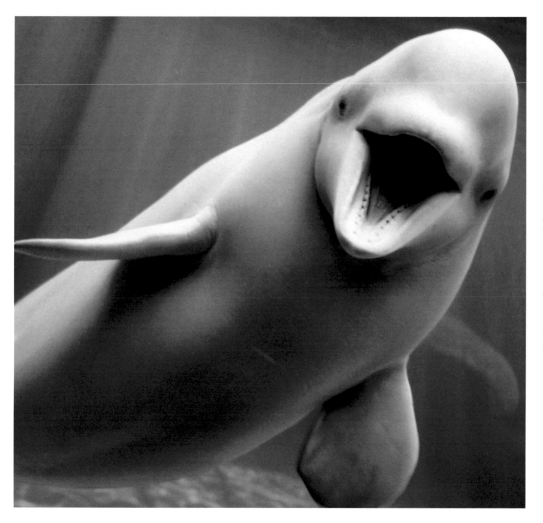

It's actually pretty easy.

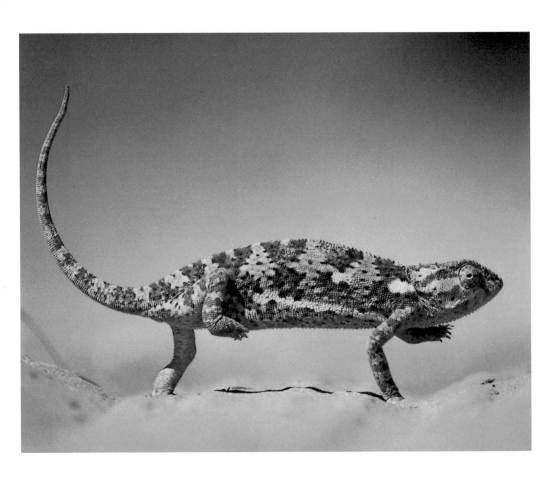

First, stop slinking away from all those nagging issues.
It's time to face the music.

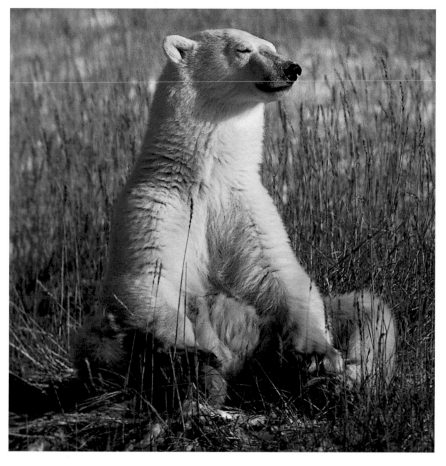

Now, just relax. Take some deep breaths
(in through the nose and out through the mouth).
Try to meditate if you can.

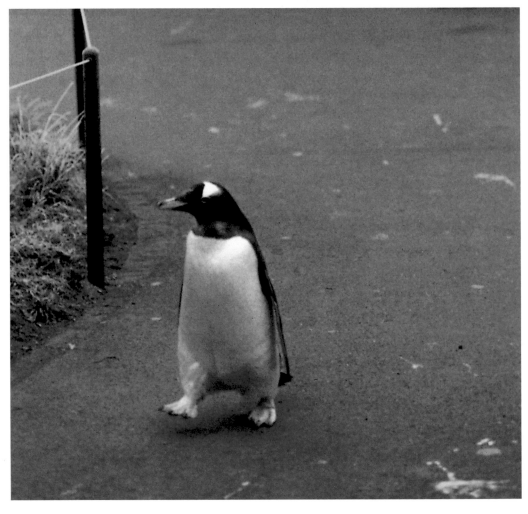

Or go for a walk to clear your head.

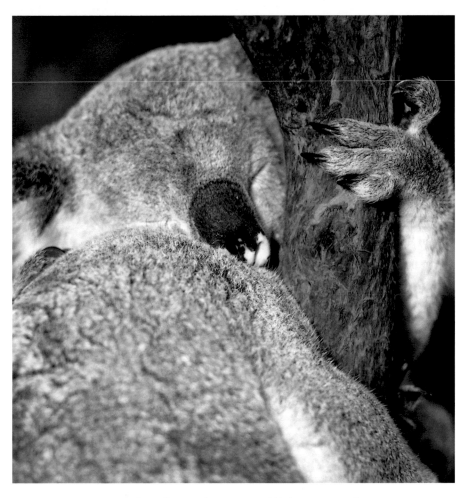

Accept the fact that you'll have to let go
of some emotional baggage.

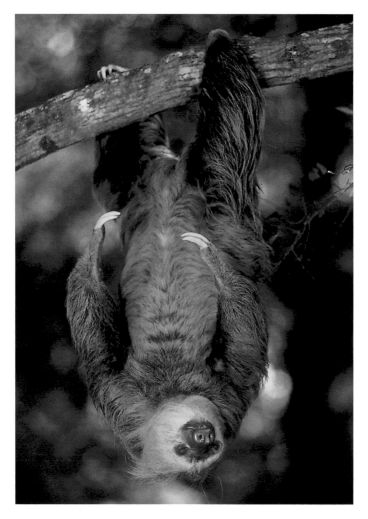

Try seeing things from a different perspective.

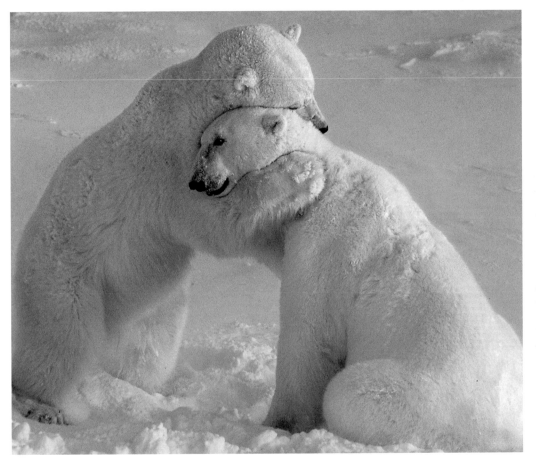

Maybe you're actually the one at fault.
If that's the case, be big enough to say you're sorry
(it's never too late to do this).

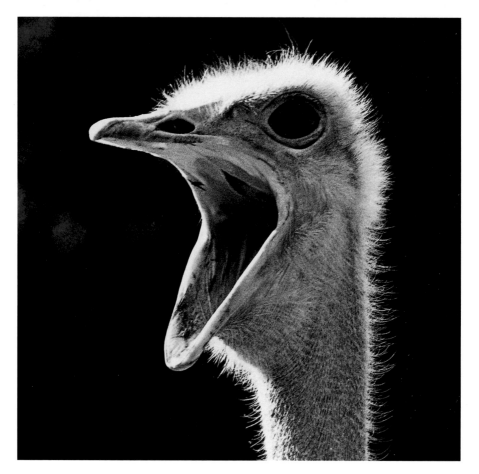

If someone else is doing the wrong thing, then step forward bravely and say, "That's not right and I won't stand for it!" When truth and justice are at stake, it's okay to be forceful.

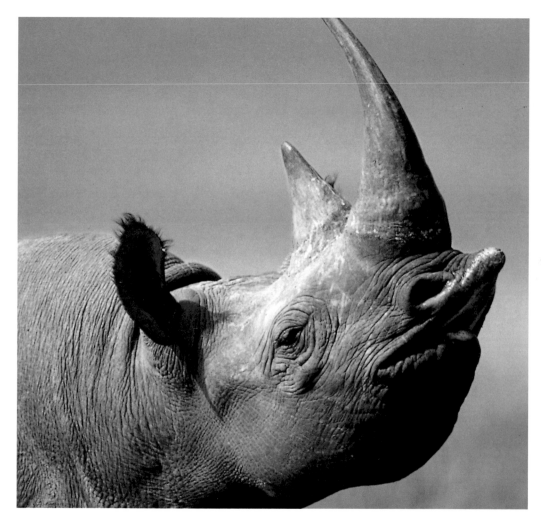

(It's rarely okay to blow raspberries.)

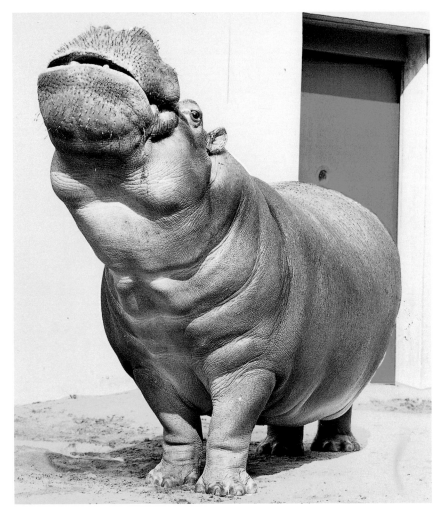

Be proud of who you are,

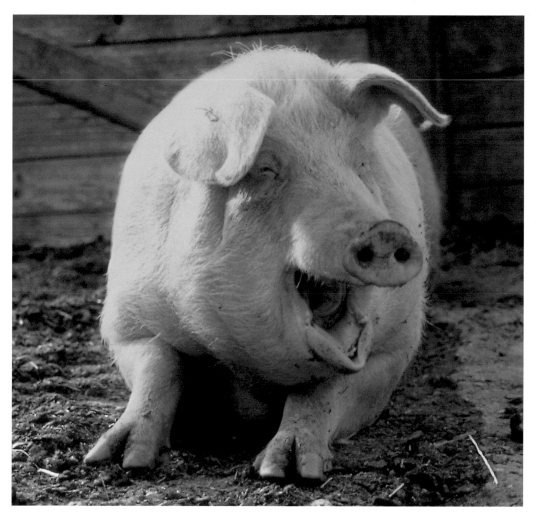

but don't lose the ability to laugh at yourself.

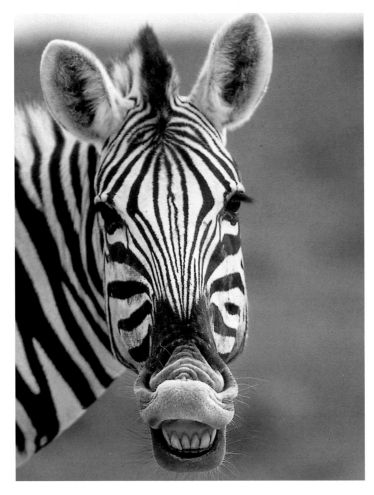

(This is a lot easier when you associate
with positive people.)

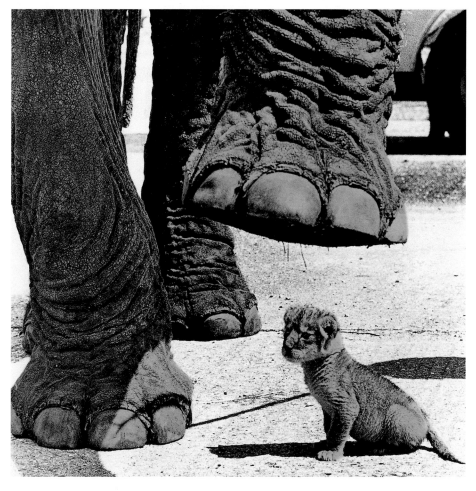

Live every day as if it were your last,
because one day it will be.

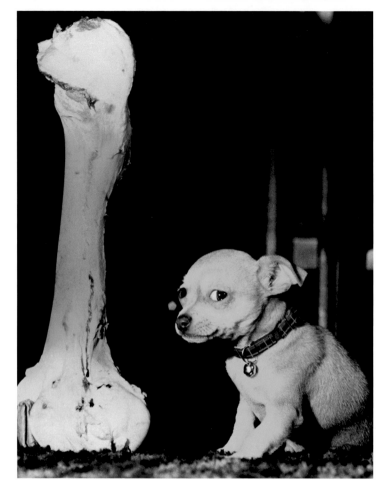

Don't be afraid to bite off
more than you can chew.

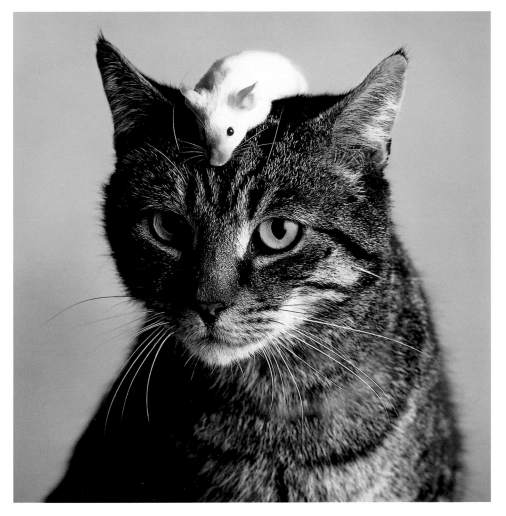

Take big risks.

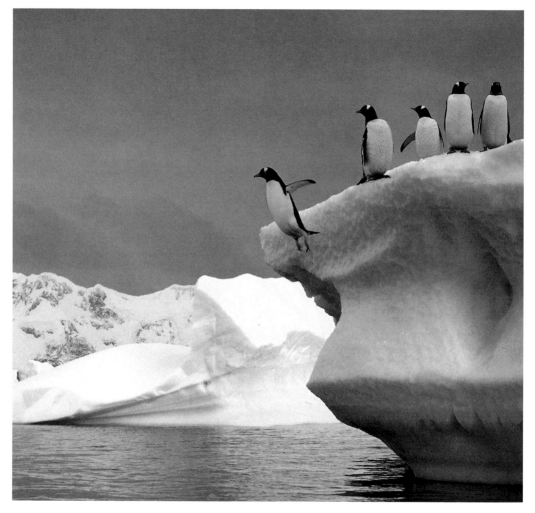

Never hang back. Get out there and go for it.

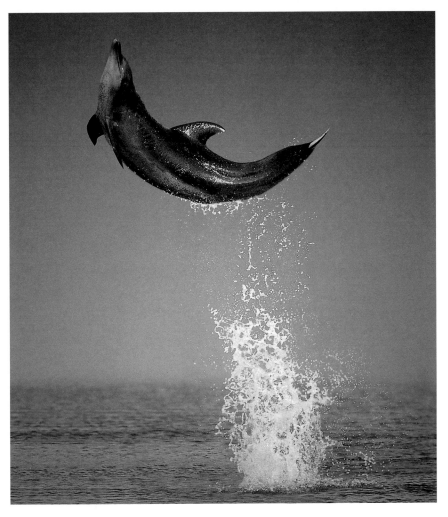

After all, isn't that what life is all about?

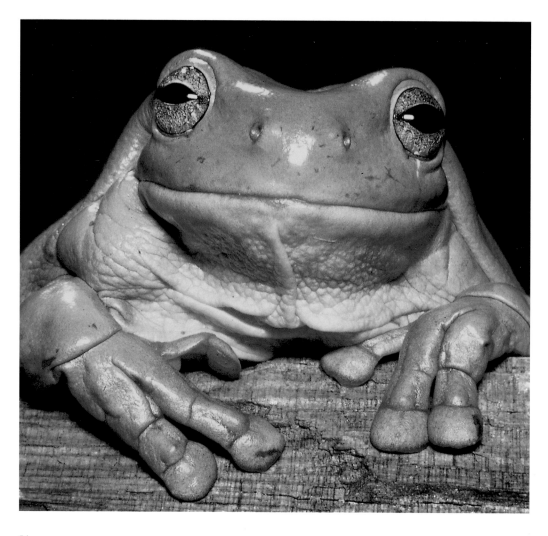

I think so too.

BRADLEY TREVOR GREIVE AM (Yáa Gí Yéil) is a proud Tasmanian and the world's bestselling humorist, having sold more than 30 million books in 115 countries. BTG is a graduate of Australia's Royal Military College and is a former paratrooper commander; he is also a television presenter, Polynesian rock-lifting champion, qualified cosmonaut, and a celebrated wildlife conservationist. In 2014, BTG was awarded the Order of Australia for his service to literature and wildlife conservation, and he is an adopted member of the Tlingit Deisheetaan clan of Kootznoowoo, an island in southeast Alaska where he has spent many years researching brown bears. BTG lives in Australia and the United States with his wife and daughter.